W9-CKL-025

Black Angels

The art and spirituality of Ethiopia

RICHARD MARSH

Text copyright ©1998 Richard Marsh
This edition copyright © 1998 Lion Publishing
The author asserts the moral right to be identified as the author of this work

Published by
Lion Publishing plc
Sandy Lane West, Oxford, England
ISBN 0 7459 3936 8
First edition 1998
10 9 8 7 6 5 4 3 2 1 0

All rights reserved
A catalogue record for this book is available from the British Library
Printed and bound in Singapore

Acknowledgments
'Anaphora of Our Lady' and 'Anaphora of Our Lord Jesus Christ', p. 66, and 'The
Eucharistic Thanksgiving of Saint Discorus', p. 113, from *The Anaphorus of the Ethiopic
Liturgy* by J.M. Harden. Copyright © SPCK, 1928. Used by permission of SPCK.
Hymn from *Kebre Negest*, Glory of the Kings, copyright © The Anglican Book Centre,
Toronto.
Quotation from *Fetha Negest*, the Law of the Kings in *Light from the East: A Symposium of
the Oriental, Orthodox and Assyrian Churches*, p. 76, ed. H. Hill, copyright © 1988 The
Anglican Book Centre, Toronto.
'The Prayer of the Saints', 'The Liturgy of the Eucharist', 'Prayers for the Whole
Church', p. 145, Prayer of Benediction, p. 139, from *Eastern Christian Liturgies: The
Armenian, Coptic and Syrian Rites* by P.D. Day, copyright © 1972 Irish University Press,
Shannon.
Photographic credits
Christian Aid: pages 2–3, 7, 12–13, 24, 25, 26, 46–47, 48, 49, 52, 63;
Jonathan Sewell: page 31;
Meryl Doney: pages 22, 35, 38–39, 40, 41;
The British Library: cover (Or 635 f23r); pages 23 (Or 584 f232r), 28–29 (Or 516,
f100v), 44&45 (Or 533, f115);
Richard Marsh: pages 17, 43;
Peter Bennett: pages 10–11, 14, 18, 19, 20–21, 30, 33, 36–37, 50–51, 55, 59, 61;
Dominic Harcourt-Webster: pages 8, 27, 60;
Sonia Halliday: page 57;
Photography for page 43, Andrew Whittuck.

*Cover picture: Mary and her beloved Son Jesus
from the seventeenth-century manuscript of the
Ta'amra Maryam, The Miracles of Mary.
Mary is seen being honoured by her Son in heaven,
surrounded by a host of angels.*

Contents

For Elizabeth

I should like to thank all those who have helped introduce me to the wonders of Ethiopia, and all those who have made this book possible.

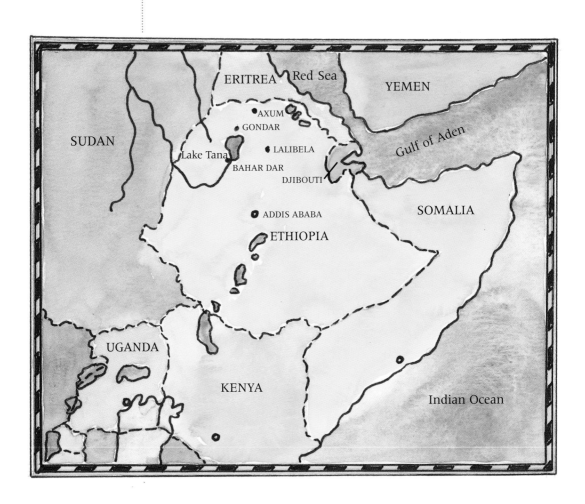

It was a chilly morning when I first arrived in Addis Ababa, the capital of Ethiopia. Few of the passengers from my plane were finishing their journey there, so only a handful of us negotiated our way through the airport. Tiredness made even filling in the simplest of forms a trial and I was grateful for the help of a young man who guided me through the bureaucracy. At the baggage carousel he asked whether I had been to Ethiopia before. I replied that it was my first visit to Africa. He looked at me enquiringly, 'So,' he asked, 'do you really think that Ethiopia is in Africa?' His question seemed too preposterous to require a reply, and anyway I was tired and confused. Only later, when I began to come to some sort of terms with this extraordinary land, did I begin to grasp something of its significance.

Of course Ethiopia is in Africa, but there is something more—something 'other'—about the country. This book is about that 'something more', the unique blend of culture and history which makes up Ethiopia. And it is especially about the Ethiopian Orthodox church, to which the majority of Christians in Ethiopia belong. I make no claim to be an expert, but I am an enthusiast for a country and a faith community which I find both intriguing and inspiring.

Introduction

A living faith

On our way into Addis Ababa from the airport that day, we came across crowds of people returning from a religious festival. They thronged the streets exuberantly. Later, flying in a small aircraft over the highlands, I was struck by the hundreds of round, thatched churches which punctuate the landscape, each within walking distance of a village.

Visiting these churches, either in the early morning or at other times when services were not being performed, there were always people in the church compound. Some attended upon the priests as they said morning or evening prayer. Others, touching the outside wall of the church with great devotion, said their own prayers.

There is a depth of faith and a profound and complex cultural heritage

in Ethiopian Christianity. A good example of this is the extraordinary complex of rock churches at Lalibela. The story of their building is included in the section on myths and legends. Hewn from solid rock they have been called the eighth wonder of the world. Beyond the sheer extraordinariness of their physical construction is an overview of biblical history from creation to judgment designed to teach the faith and making it possible for Christians to 'make a pilgrimage while staying at home'.

If there is one word that characterizes Christianity in Ethiopia, it is *richness*. The worship is vibrant, with priests and deacons in brightly coloured vestments carrying splendidly gaudy liturgical umbrellas. The music is a mixture of chants of Semitic origin and African rhythms, accompanied on distinctive goatskin drums. The walls and ceilings of the churches are brightly, even luridly, painted with scenes from the Bible or from the lives of the saints. The language of prayer and liturgy is rich with resonances and echoes from scripture and from the fathers of the early church.

Beginnings

Although the Book of Acts contains the story of the conversion to Christianity of the Ethiopian Eunuch, it is really to the fourth-century historian Rufinus that we have to look for the beginnings of Ethiopian Christianity. He tells the tale of Frumentius and Aedesius, two young Roman men, who arrived on the Ethiopian coast and made their way to the royal court at Axum in the north of the country. The two wielded a strong influence over the court and especially over the king's mother. The influence was so great that Frumentius was able to encourage merchants from outside Ethiopia to build churches for their own use in Axum. When, eventually, Frumentius was allowed to leave, he went to Alexandria and informed Bishop Athanasius that there were Christians in Ethiopia. The bishop promptly consecrated him a bishop and sent him back as chief pastor to the court at Axum—which was probably not quite what he had intended. In the Ethiopian tradition, Frumentius is known as Abba Selema, or 'Father of Peace'. This is a hymn celebrating his memory:

With joyful voice I greet him,
Praising and magnifying him
Selema, gate of mercy and of grace,
Who made the glorious splendour of Christ
Shine in Ethiopia;
Where before there was night and darkness.

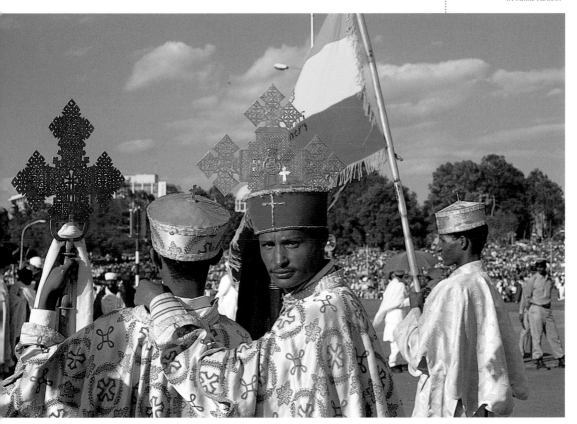

Priests holding their own churches' processional crosses celebrate the Festival of Mesqel in Addis Ababa.

To the outside observer, there is much in the life and witness of the Ethiopian Church that is in common with the other churches of the Oriental Orthodox family, which includes the Egyptian Coptic, Armenian and Syrian Churches.

Modern icons are carried as part of a festival procession. They are followed by the tabot, carried on the head of a priest.

However, there are also elements which set Ethiopian Christianity apart and contribute to its uniqueness. For much of its history Ethiopia has been geographically and culturally isolated. Stories of the fabulous wealth of its legendary ruler, Prester John, circulated in Europe during the Middle Ages, adding to the romance of its reputation. In fact, Ethiopian Christianity reveals its indebtedness to a wealth of different religious and artistic traditions. Eastern and Western Christianity are the most important of these, but there

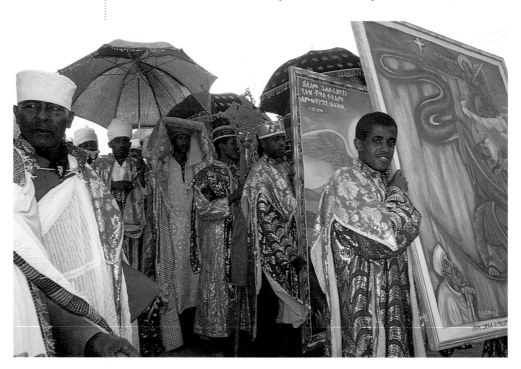

are also influences from Islam and Judaism. This latter is seen especially in regulations about circumcision and diet. Certainly, until relatively recently there were substantial numbers of black Jews or *Felashas* living in Ethiopia.

The account of how the Ark of the Covenant came to Ethiopia is one of the foundational legends of the church's religious identity. Replicas of the Ark, or rather the tablets upon which Moses inscribed the Ten Commandments, are known as *tabots*. They are an essential element of every Ethiopian Orthodox church and on festivals they are carried in procession on the heads of the priests. *Tabots* are regarded as having great spiritual power and are always carefully wrapped up in brightly coloured cloths. The Ark itself is said to be housed in a small chapel next to the great church of St Mary of Zion in Axum.

Although for centuries the Coptic Patriarchate of Alexandria appointed the church leadership, since 1957, the Ethiopian Orthodox Church has elected its own Patriarch or *Abuna* who, together with the Holy Synod and local bishops, governs the Church. There are many thousands of churches and one estimate puts the number of priests at around 200,000 with many more boy deacons, only some of whom will become priests. The church also preserves in its canon of scripture some Old Testament Apocryphal material not found elsewhere, for instance the whole of the Book of Enoch.

All these different strands weave together into the glorious synthesis which is Ethiopian Christianity, a tradition which has the capacity to enthral, entice and open new windows onto our own spirituality and sense of mystery.
Richard Marsh

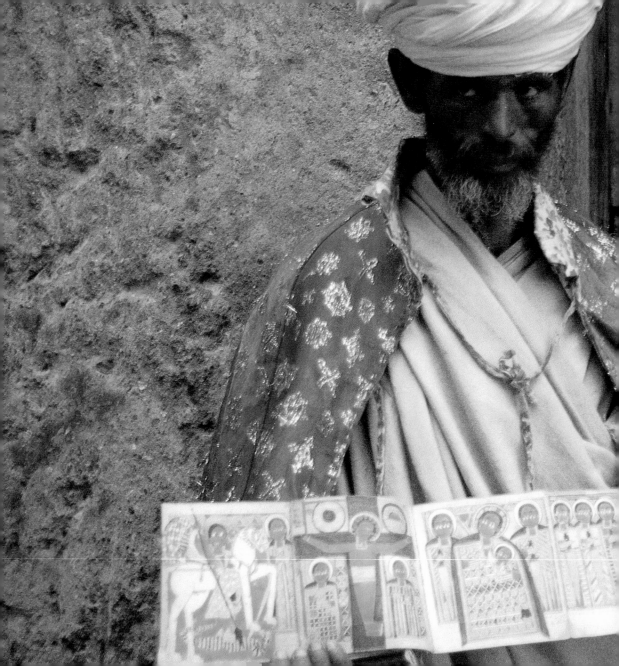

Myths and legends

At the Church of Ashetun Marium, in the hills high above Lalibela, the priest shows one of his church's treasures. This folded parchment strip, called a sensul, is painted in the same seventeenth-century style as the Four Gospels manuscript (see page 28). The subjects (left to right) are St George and the dragon, the crucifixion, Mary, St Luke and the four kings of the Zagwe dynasty.

Solomon and the Queen of Sheba

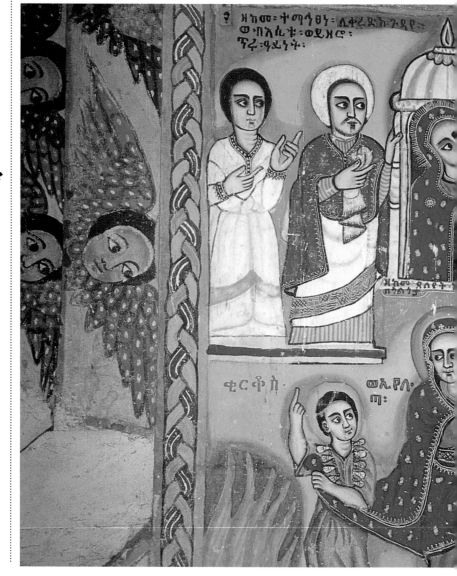

The Queen of Sheba visits King Solomon. A modern wall-painting, based on eighteenth-century style, in a monastery near Bahir Dar, on Lake Tana.

12

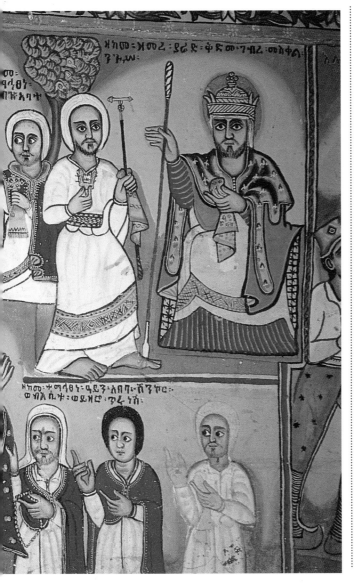

የአይሆም ንጉሠ ሦሎሙ ፡ ንፉ ፡ ቅ ም ም ፡ ኀ ብ ጴ ፡ ፡ ጋ ወ ጳ ፡ ም በ ሲ ፣ ም ም ፡ ም ም ም ም ም ም ም ም
ንጉሠ ም በ አ በ ም

ዘኸ ም ፡ ተ ም ብ ም ም ፡ ም ም ፡ ም ም ም ም ም ም ም ም ም ም ም ም ም ም ም
ወ ም ም ም ም ም ም ም ም ም ም ም ም ም ም ም ም ም

Storytelling is one way in which a community defines itself. The Ethiopian Christian tradition is rich in stories. One of the most important tells of how the Ark of the Covenant, the box containing the tablets on which the Ten Commandments were written, came to find its way to Ethiopia. Not only is it the story of the Ark, but also it expresses the special relationship to God which is at the heart of Ethiopian Christian consciousness.

Ethiopian Christians see themselves in direct succession to the people of Israel as being chosen, or set apart by God. This story, which is depicted on the walls of churches, in manuscripts, and which I even saw adorning the walls of a restaurant, expresses this sense of being directly descended from Solomon and the twelve tribes of Israel.

The most complete account of the legend is found in the *Kebre Negest*, or Glory of the Kings. It tells of how the Queen of Sheba visits King Solomon in Jerusalem. The Queen of Sheba is believed by Ethiopians to have come from Axum in the Tigray region of Ethiopia. The story is a development

13

of the biblical account of the visit in the Book of Kings. The queen, whose name is Makeda, visits Solomon, bearing extravagant gifts. She is welcomed at Solomon's court where she stays several months. On the night before she returns home, Makeda and Solomon sleep together, after which Solomon has an

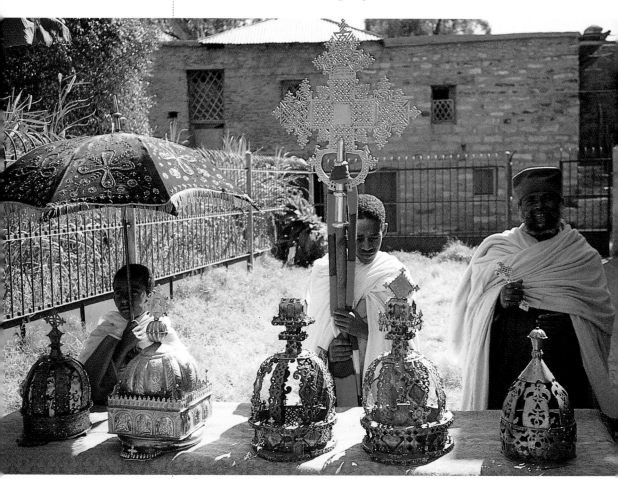

unnerving dream about what the future will hold for him and for Israel.

And the Queen rejoiced, and she went forth in order to depart, and the King set her on her way with great pomp and ceremony. And Solomon took her aside so that they might be alone together, and he took off the ring that was upon his little finger, and he gave it to the Queen, and said unto her, 'Take [this] so that thou mayest not forget me. And if it happen that I obtain seed from thee, this ring shall be unto it a sign, and if it be a man child he shall come to me; and the peace of God be with thee! Whilst I was sleeping with thee I saw many visions in a dream, [and it seemed] as if a sun had risen upon Israel, but it snatched itself away and flew.

Of course, Makeda is pregnant. She has a son whom she names Menelik.

And the pains of childbirth laid hold upon her, and she brought forth a man child, and she gave it to the nurse with great pride and delight… And the child reached the age of twelve years, and he asked his friends among the boys who were being educated with him, and said unto them, 'Who is my father?' And they said unto him, 'Solomon the King.'

Makeda tries to dissuade her son from visiting his father in Israel:

'… His country is far away, and the road thither is very difficult; wouldst thou not rather be here?'… And he said unto the Queen, 'I will go and look upon the face of my father, and I will come back here by the Will of God, the Lord of Israel.'

So the young Menelik retraces his mother's footsteps to the court of King Solomon.

The silver and gold crowns belonging to Ethiopia's rulers are housed in the Church of Saint Mary of Zion, Axum. The sanctuary chapel of the Ark of the Covenant is said to be the last resting-place of the lost Ark from the temple at Jerusalem.

15

The Ark of the Covenant

When Menelik arrives in Jerusalem he is recognized and welcomed by Solomon. As Solomon's son and eldest heir, he is offered the throne of Israel and a priceless legacy:

And the Tabernacle of the God of Israel shall belong to thee and to thy seed, whereto thou shalt make offerings and make prayers to ascend. And God shall dwell within it for ever and shall hear thy prayers therein, and thou shalt do the good pleasure of God therein, and thy remembrance shall be in it from generation to generation.

However, Menelik declines the throne of Israel:

And his son answered and said unto him, 'O my lord, it is impossible for me to leave my country and my mother, for my mother made me swear by her breasts that I would not remain here but would return to her quickly, and also that I would not marry a wife here. And the Tabernacle of the God of Israel shall bless me wheresoever I shall be, and thy prayer shall accompany me whithersoever I go. I desired to see thy face, and to hear thy voice, and to receive thy blessing, and now I desire to depart to my mother in safety'.

Menelik determines to steal the Ark. He obtains it by means of subterfuge and with a little local help. He sets out accompanied by the sons of some of the nobles in Solomon's court. They arrive back in Ethiopia amid much rejoicing, the triumphant procession led by the Archangel Michael. Queen Makeda abdicates in favour of her son who thereafter governs Ethiopia.

Thus hath God made for the King of Ethiopia more glory, and grace and majesty than for all the other kings of the earth because of the greatness of Zion, the Tabernacle of the Law of God, the heavenly Zion. And may God make us to perform his spiritual good pleasure, and deliver us from His wrath, and make us to share his kingdom.

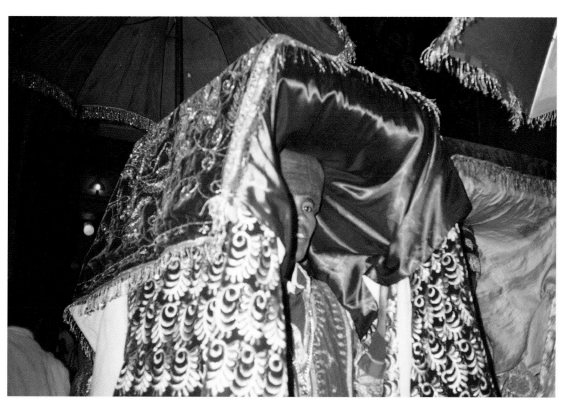

*On all major festivals the tabots,
stone or wooden tablets symbolizing
the Ark of the Covenent, are wrapped
in fabric and carried on the heads of
the priests. This is the Feast of St
Mary in Addis Ababa.*

17

Churches in the rock

Another important legend tells the story of King Lalibela, the twelfth-century Zagwe monarch credited with executing the extraordinary series of churches carved from solid rock in the highland town that now bears his name. A life of Lalibela reveals the meaning of this name.

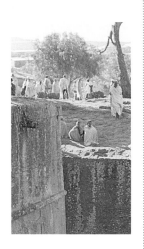

When his mother bare him, many bees came and swarmed around him, even as they swarm around honey. And his mother saw that the bees swarmed and thronged around her son as the host surrounds the king. And when she saw this, there descended on her the spirit of prophecy, and she said, 'The bees know that the child is great.' Therefore she named him Lalibela, which means, 'The bees know his grace.'

The Ethiopic Synaxarium, or Breviary, gives the traditional account of his life. He was raised as a saintly boy by his parents. One day in a fit of jealousy, his elder brother, who had become king, had him tried on a false charge and flogged for six hours. At the end of this time everyone was amazed to find that there was not a scratch on him.

It was that an angel had protected him. And then the king said unto him, 'Forgive me, my brother, for what I have done unto thee.' Then were they reconciled and at peace, the one with the other. And God regarded his torments on that day, and made him to inherit, and gave him the kingdom. And when he became king, he bethought him how he might please God, and gave much alms to the poor and needy. And when God saw the strength of his love, the angel of God appeared unto him in a dream and carried him away unto God. And He showed him how to build the churches of varied shape; and he did as God had showed him. And when he had finished building these churches, he delivered the kingdom to his brother's son and then rested in peace.

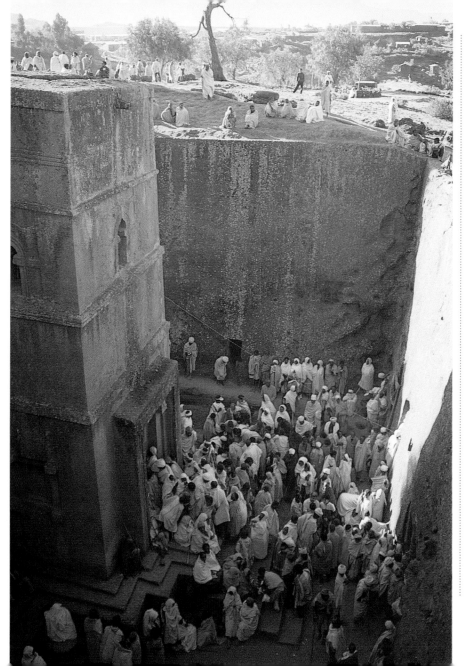

Carved into solid rock, the churches of Lalibela are often considered to be the eighth wonder of the world. Here pilgrims assemble before Christmas Eve. Many have come long distances to celebrate the Feast of Christmas at the Church of Bet Giyorgis.

19

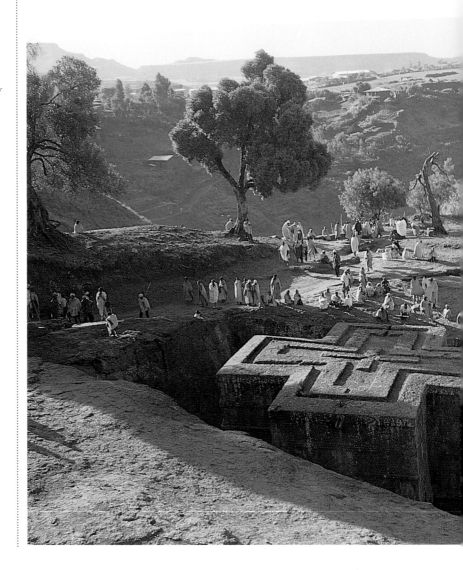

This view of the Church of Bet Giyorgis shows its cruciform shape and the way in which it has been excavated from solid rock.

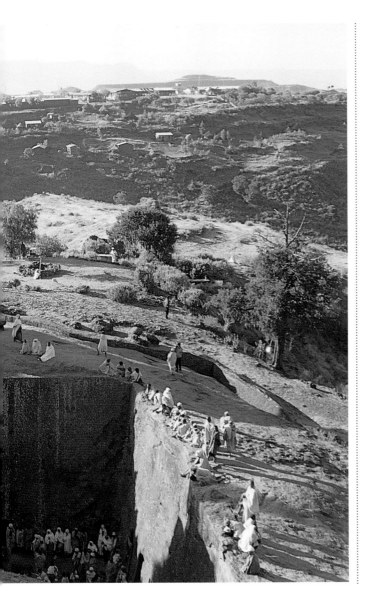

Certainly the rock churches of Lalibela are among the most extra-ordinary constructions in Christendom. Not only are they hewn from the solid rock, but also the whole of biblical history is recreated within them. For example, the 'graves' of Abraham and the other Old Testament patriarchs are to be found in one church, while another is separated into two halves, one of them Golgotha, the tomb of Christ, where visitors are shown Lalibela's own tomb.

It has been argued that the whole complex was built by Lalibela, as a place of pilgrimage within Ethiopia, which would be safer than the long and often perilous journey to Palestine. Whatever the reason, the whole area is a magical and holy place, a *tour de force* of religious imagination.

21

St Yared is considered to be the father of Ethiopian church music. He is credited with having learned from the birds the music which forms the basis of Ethiopian worship. Many of his hymns are still used in the church's worship.

The gift of music

Now in those days there was no singing of hymns and spiritual songs in a loud voice to well-defined tunes, but men murmured them in a low voice. And God, wishing to raise up to Himself a memorial, sent unto him (Yared) three birds from the Garden of Edom, and they held converse with Yared in the speech of man, and they caught him up, and took him to the heavenly Jerusalem, and there he learned the songs of the Four and Twenty Priests of heaven. And when he returned to himself, he went into the First Church in Aksum, at the third hour of the day, and he cried out with a loud voice, saying, 'Hallelujah to the Father, Hallelujah to the Son, and Hallelujah to the Holy Spirit.' The first Hallelujah he made the foundation and called it 'Zion'. In the second Hallelujah he shewed forth how Moses carried out the work of the tabernacle and this he called a 'Song of the heights' And when they heard the sound of his voice, the king, and the queen, and the bishop, and the priests, and the king's nobles ran to the church, and they spent the day in listening to him.

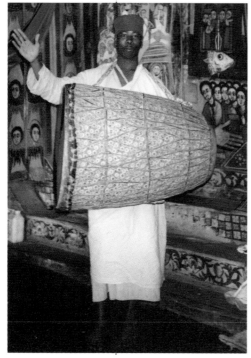

A musician or debtera in the tradition of St Yared, outside a typical Ethiopian round church. It is surmounted with a crown of ostrich eggs, symbolizing the resurrection.

A young priest plays a traditional drum called a kabaro.

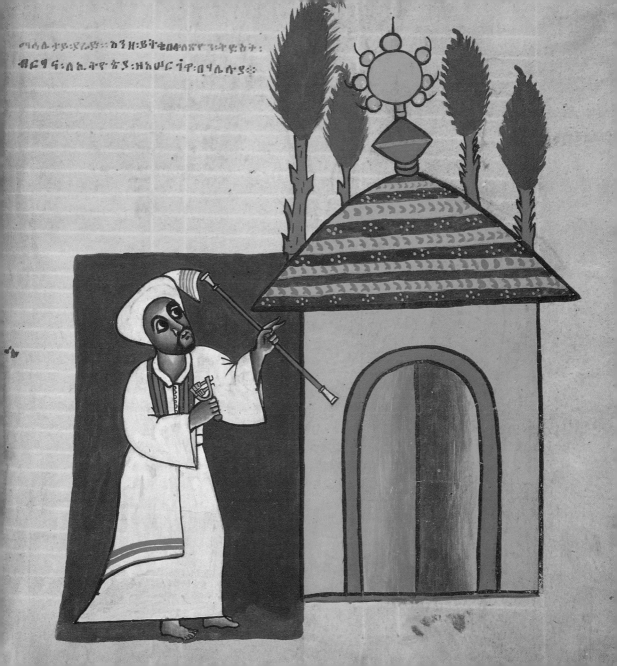

Attending worship in the Ethiopian Church is an exciting and, for some westerners, an exhausting experience. The celebrations can last many hours and even overnight. Some rest their weight on traditional prayer sticks.

The churches themselves are divided into several parts; the Holy of Holies in the centre is reserved for the priests and deacons, another area is for those few people who will receive communion. A third is for the *debteras*, or choirmen.

Debteras have an important position within the church. Distinctively dressed in white shawls and shaking *sistra*, or rattles, they sing accompanied by goatskin drums. Following the Old Testament story of King David dancing before the Lord, they dance a long, sinuous dance of praise. They represent a special group of men educated not only in music and liturgy but often in traditional forms of healing.

Debteras singing at the Feast of Mesqel in Addis Ababa. They carry prayer sticks and maintain the rhythm of the song with the sistrum, or rattle.

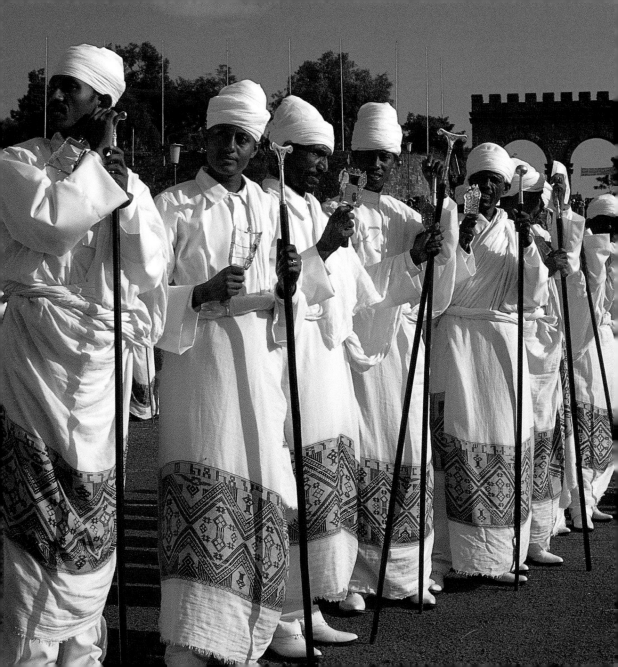

Ethiopia's crosses

A personal hand cross, carried by a priest.

The central symbol of the cross is to be found everywhere. Many Ethiopian Christians wear wooden or metal crosses around their necks and some women even have magnificent tattooed crosses on their faces. All priests carry small hand crosses which are reverently kissed by the faithful.

By far the most magnificent and striking are the large processional crosses of ornate metalwork festooned with brightly coloured cloths. These vary in design, depending on which region of the country they come from, but all are exuberant in their designs. The artists who make them are expressing their understanding of the cross as the source of life as well as the place of death.

Deacon:
Pray before the Cross,
All you, the faithful,
Holding it on the right
And renouncing Satan,
For it has been sanctified by the blood of Christ the Saviour.

Congregation:
Honoured art thou, O Cross, King of woods,
Honoured art thou, O Cross.
And honoured is the blood of the Divinity, the Word which sanctified thee.

Priest:
In honour of this Cross,
We Christians prostrate ourselves with fear and awe,
For the Son himself in person
Hath sanctified it with his blood, not with that of others,
When, on the Cross,
Divinity died in his humanity…

Daily office prayers from the Qeddase

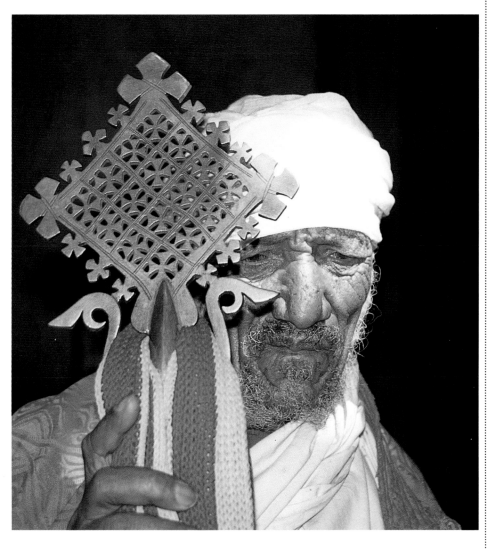

Each church has its own processional cross and each region its characteristic shape. The holes at the base carry the long fabric scarves that hang from the cross at festivals.

This portrait shows St George slaying the dragon and rescuing the young woman of Beirut, who holds the dragon's tether. It is painted opposite St Luke in a seventeenth-century manuscript of the Four Gospels held in the British Library. It is unusual in style and may have been the work of an individual artist working near Lalibela.

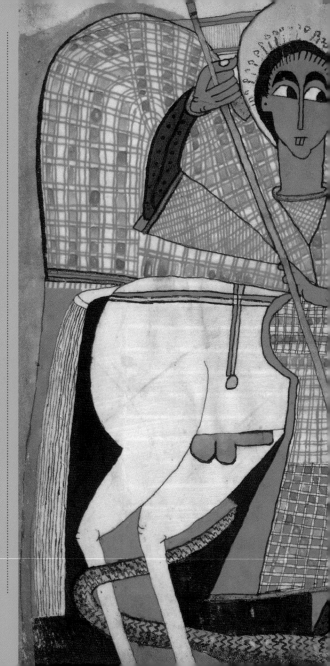

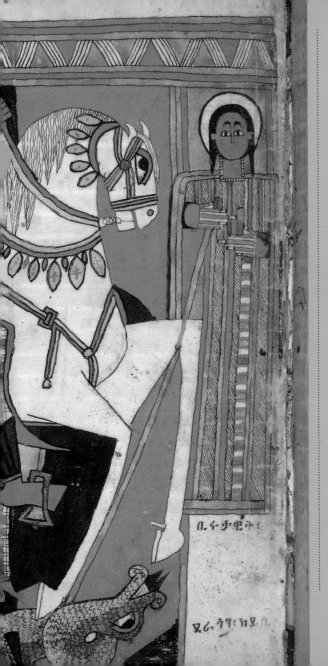

Saints
and
angels

Mary the mother of Jesus

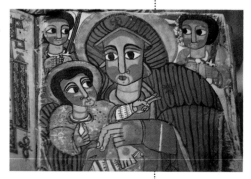

Mary and Jesus flanked by two archangels from the Church of Na'akuto La'ab at Lalibela.

P robably the most important saint is Mary. She is addressed with such passion that she almost appears to be the fourth person of the Holy Trinity. But the following extract gives the lie to this. Certainly she is important, but that importance has to do with her unique role in being the *theotokos* or God-bearer, a definition adopted by the universal church at the Council of Ephesus. This extract comes from the *anaphoras*, or Eucharistic prayers.

The deacon saith: *Look to the east.*

The priest saith: *Verily God the Father hath looked from heaven… and found none like Thee… and sent His Son to Thee whom He loved.*

The deacon saith: *We are attending.*

The priest saith: *Holy is God the Father who was well pleased in Thee; Holy is the Only-begotten Son who dwelt in Thy womb; Holy is the Paraclete, the Spirit of Truth who strengthened Thee.*

The deacon saith: *Answer ye.*

The priest saith: *O Virgin, full of praise, with whom and unto whom shall we liken Thee? Thou art the loom out of whom Emmanuel put on the inexplicable clothing of the body. He made the warp of the original flesh of Adam and the woof of thy flesh; and his reed was the Word, Jesus Christ Himself, and His shuttle was the overshadowing from above of the Most High God and the weaver was the Holy Spirit.*

The Anaphora of Our Lady

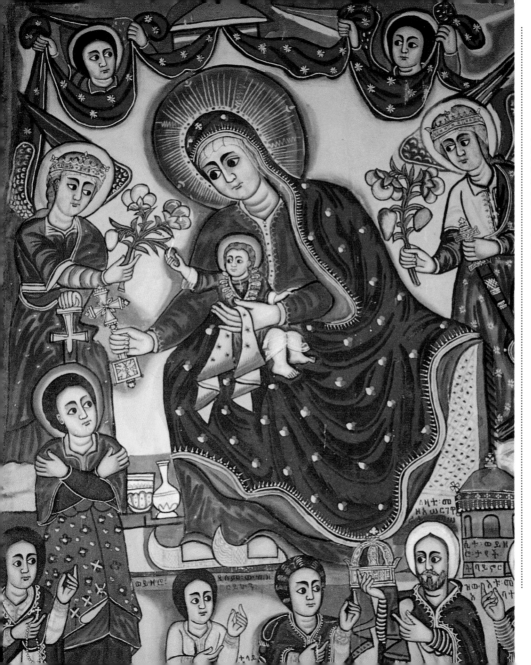

A modern wall-painting of Mary in the Monastery of Bahir Dar. She holds an Ethiopian hand cross in her right hand. The paintings on these two pages demonstrate contrasting styles.

31

For all the saints

Ethiopian Churches are a riot of colour and images. Scenes from the life of Christ jostle with images of the saints and angels. Ethiopian Christians have retained a strong consciousness of the proximity and immediacy of the divine and the saints are part of this. They are celebrated and invoked in formal acts of worship but are also very much a part of the daily prayer and personal devotion of Ethiopian Christians. The saints, the angels, patriarchs and prophets all combine in this great prayer of praise and thanksgiving.

The wall fresco of a saint from the Church of Debre Sina Maryam at Gorgora on the Northern shores of Lake Tana. He has a turban and halo and carries a hand cross and prayer stick. He may depict Abuna Tekla Haymanot, 'father of all the monks', or Abuna Estifanos, founder of the monastery at Gunda Gundie.

Michael was given the mission of mercy to bring God's messages to the world, while Gabriel brought a heavenly gift to the blessed virgin Mary.

Understanding was David's gift, while wisdom was given to Solomon, and Samuel was presented with a horn of oil because he anointed the kings.

Peter was given the keys of the Kingdom, while virginity was John's gift and apostleship was given to our father Paul, because he was the light of the church.

While Moses was given the law, Aaron was given the priesthood and Zacharias was presented with chosen incense. They prepared a tabernacle according to the Word of God and Aaron offered incense.

The Seraphim and Cherubim worship and praise him saying: Holy, Holy, Holy is the Lord God, and his honour extends beyond all his creation.

From the Prayer of the Saints

32

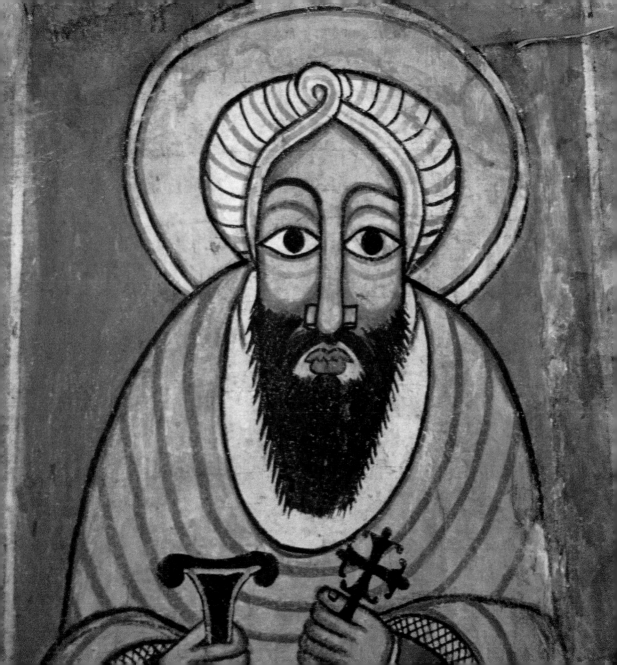

Hosts of angels

Many observers have noted the Ethiopian preoccupation with angels. One reason for this may be traced to those books in the Ethiopian Bible which do not appear either in the Western or Eastern canons. Some of these only exist in their complete forms in the ancient liturgical language of Ethiopia, *Ge'ez*. One of these is the Book of Enoch. In this quotation from Chapter 71, the writer is fulsome in his depiction of the heavenly realm:

And it came to pass after this that my spirit was translated
And it ascended into the heavens:
And I saw the holy sons of God.
They were stepping on flames of fire:
Their garments were white [and their raiment],
And their faces shone like snow.
 And I saw two streams of fire,
And the light of that fire shone like hyacinth,
And I fell on my face before the Lord of Spirits.
 And the angel Michael [one of the archangels]
seized me by my right hand,
And lifted me up and led me forth into all the secrets,
And he showed me all the secrets of righteousness. And he
showed me all the secrets of the ends of the heaven,
And all the chambers of all the stars, and all the luminaries,
Whence they proceed before the face of the holy ones.
 And he translated my spirit into the heaven of heavens,
And I saw there as it were a structure built of crystals,
And between those crystals tongues of living fire.
And my spirit saw the girdle which girt that house of fire,
And on its four sides were streams full of living fire,
And they girt that house.
 And round about were Seraphim, Cherubim, and Ophannim:

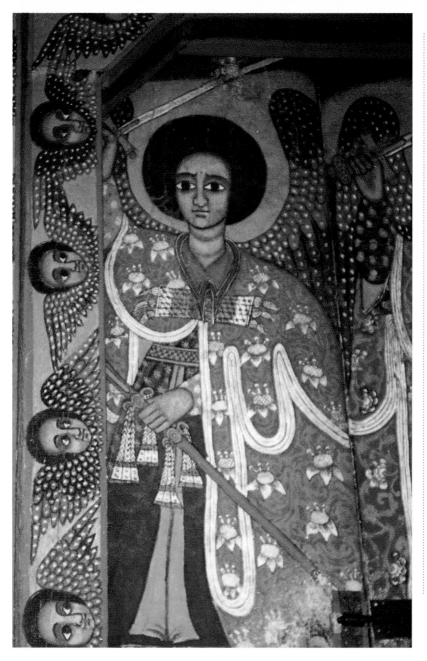

An archangel guarding the door to the inner sanctuary in the Church of Debre Sina Maryam. He is dressed as a warrior from the beginning of the Christian era and has an unsheathed sword in his hand.

35

And these are they who sleep not
And guard the throne of His glory.
 And I saw angels who could not be counted,
A thousand thousand, and ten thousand times ten thousand,
Encircling that house.

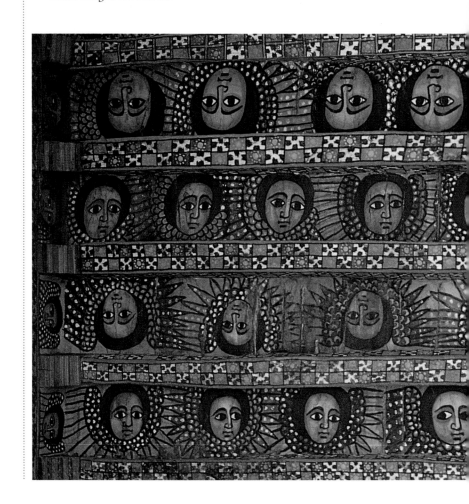

And Michael, and Raphael, and Gabriel, and Phanuel,
And the holy angels who are above the heavens,
Go in and out of that house.
From the Book of Enoch

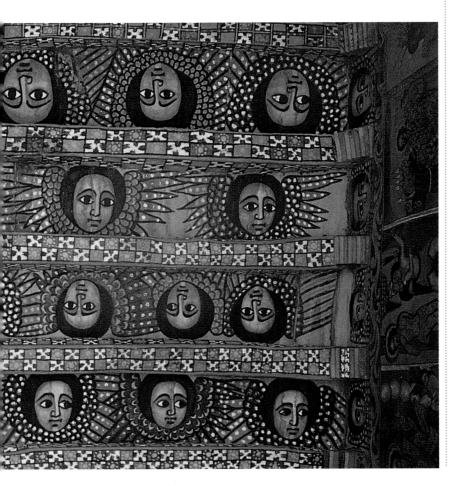

The ceiling of the Church of
Debre Birhan Selassie at Gondar
is decorated with row upon row of
winged cherubs. They may well
have been inspired by these words
from the Book of Enoch.

37

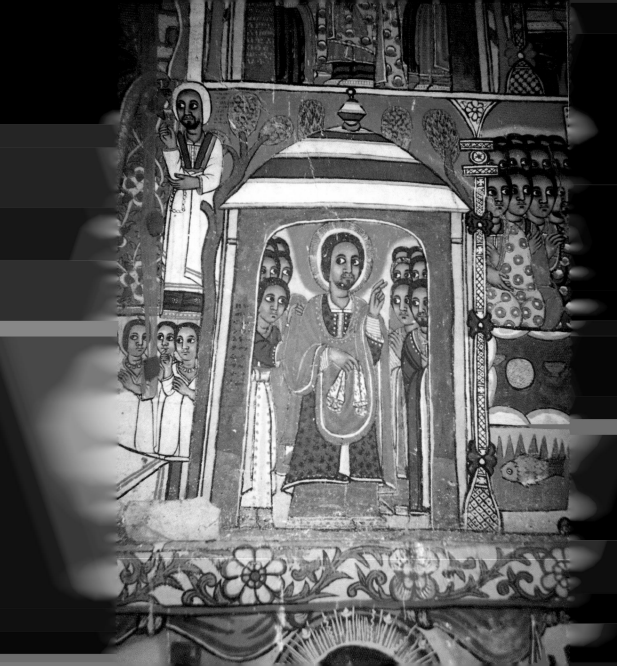

Devotion to Jesus Christ

Jesus and his disciples, from a monastery near Bahir Dar, on Lake Tana.

Christmas, festival of the incarnation

The thirteen months of the Ethiopian year are punctuated by the feasts and festivals of the church. Large crowds attend church, even during the week. There is a great and infectious sense of festivity, together with an underlying heartbeat of faithfulness. St George, St Michael and the Virgin Mary are among those saints to whom Ethiopian Christians have a special devotion. However, the overriding emphasis is on the life and work of Jesus.

This hymn for the Christmas season illustrates the rich and poetic way that Ethiopian Christians understand the mystery of Christ's incarnation. It combines motifs from the Old and New Testaments, together with typically Ethiopian emphases both on angels and Mary.

He whom heaven and earth cannot confine,
We saw him confined in a narrow chest
Having left the ninety-nine angelic hosts,
We found him today lying in a manger.

Chorus: The Men of Wisdom came
The Men of Wisdom came
Having heard the news,
The star lighting for them like a torch.

When Our Lord was born in Bethlehem
Sorrow was vanquished, and peace prevailed,
Trees bore abundant fruits
All the rivers became honey and milk.
The Wise Men came to worship him,
Asking, 'Where is the King of Israel?'
They gave the offerings according to custom,
Incense for priesthood, gold for Kingship.

Trans. Church of St Mary of Zion, London

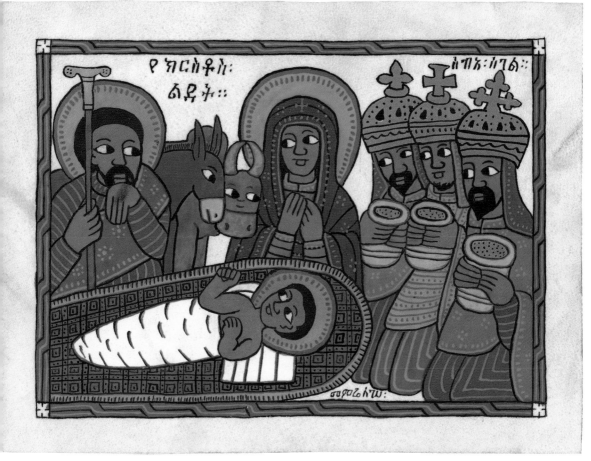

A modern painting of the nativity, on velum, follows the traditional style. Joseph carries a prayer stick and the magi wear traditional Ethiopian crowns.

Timqat, festival of Epiphany

The greatest of the festivals is Timqat. It combines the celebration of the baptism of Christ with his miracle of turning water into wine and the wedding in Cana. On the night before the festival, the people take the *tabots* out of the churches with great ceremony and excitement. They are taken in procession to spend the night beside water. The next day, the waters are blessed and the *tabots* returned to the churches. It is a time of great rejoicing and exuberance. In Addis Ababa a huge crowd gathers together with the patriarch of the church to celebrate Timqat and there is a great demonstration of enthusiasm when the waters are blessed.

The creator of all flesh lived in the womb;
he who forms infants in the womb became an infant;
they wrapped in swaddling cloths
him who was clothed with light.
He dwelt in the house of the poor as poor.
He walked as a man, yet worked as God.
Willingly he became hungry as a Son of man,
and granted many hungry people to be satisfied
with little bread according to his power.
He thirsted as a dying man,
and changed water into wine
as the one who is able to give life to all.

From the Ethiopian Orthodox liturgy

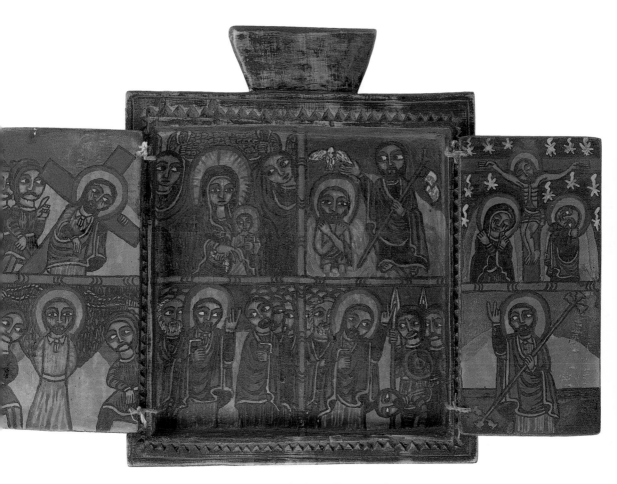

A portable, hand-carved and painted icon. It contains scenes from the life of Christ, including his baptism by John (centre top right). The Holy Spirit is descending in the form of a dove.

The eternal Christ

The eternal nature of Christ is clearly set out in the following extract from one of the fourteen prayers for the celebration of the Eucharist:

Before the world (was), and unto everlasting is God in His kingdom, God in His triune nature, God in His divinity.
Before the morning and the evening, and before the day and night; before the angels were created, was God in His kingdom.
Before the heavens were stretched forth, and before the face of the dry land appeared, before the green herbs grew, was God in his kingdom.

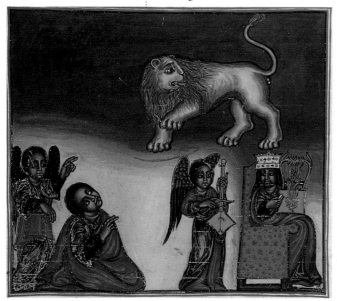

A second scene from the Apocalypse.

Before the sun and the moon and the stars, and before the orbits of the lights was God in His kingdom.
Before the beasts that move, and the birds that fly, before the creatures of the sea was God in His kingdom.
Before He created Adam in His own image and likeness, and before (man) transgressed the commandment was God in His kingdom.
Glory (be) to the Father and the Son and the Holy Spirit, now and ever and world without end.

From The Eucharistic Thanksgiving of St Dioscorus

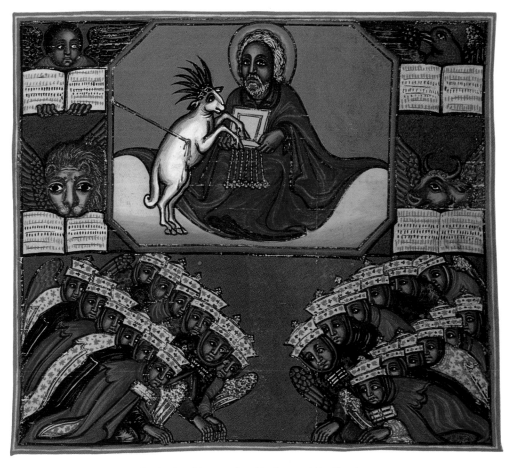

The adoration of the twenty-four elders from an eighteenth-century manuscript of the Apocalypse. The scene from the Book of Revelation is shown graphically, with God the Father presenting the Book of Seven Seals to the sacrificed lamb with seven horns and seven eyes. They are surrounded by the four heavenly beasts, the emblems of the Evangelists with their Gospels.

The Eucharist

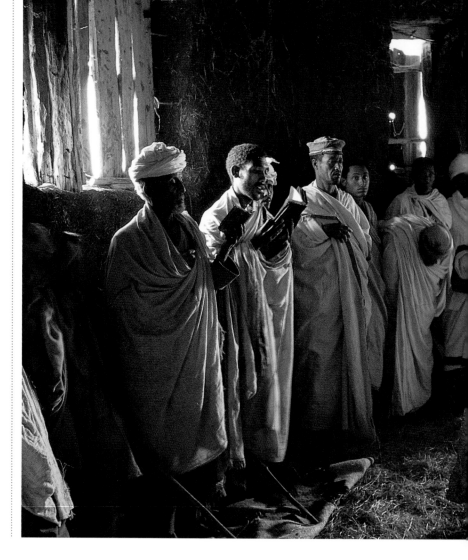

Priest Molla Yimenu celebrates the Liturgy at St Gabriel's Church Temmamit. He and his wife Worknesh Kelem are involved in running a nursery funded by the Ethiopian Orthodox Church.

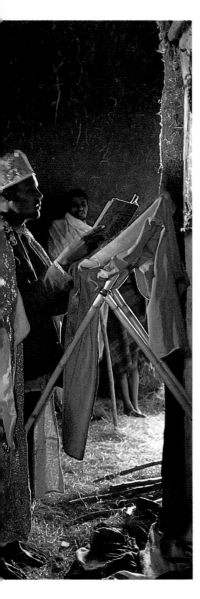

These words from the liturgy of the Eucharist, convey the Ethiopian church's deep understanding of the death and resurrection of Christ.

The priest saith: *Holy, Holy, Holy is God in His Trinity. Though He was King, He showed His humility as a servant.*

He stretched forth his hands to the passion—even He who had formed man—that He might free man from the yoke of sin. In that night in which He was betrayed He took bread in His holy and blessed hands which were without spot, He looked up to heaven to Thee His Father, He gave thanks, blessed and brake and gave to His holy disciples and pure apostles, and said unto them, Take, eat; this bread is My Body which is broken for you for the forgiveness of sin. And again, He mingled water and wine; he gave thanks, blessed and hallowed, and delivered to his holy disciples and pure apostles, and said unto them, Take, drink; this cup is My Blood which is poured out for you for a ransom for many...

He died who dieth not; He died to destroy death; he died to give life to the dead, even as He had promised them by the word of a covenant. They took him down from the tree and wrapped Him in linen clothes and buried Him in a new tomb. On the third day He rose from the dead, came to (the place) where his disciples were, and appeared to them in the upper room of Zion. And on the fortieth day, when He ascended to heaven, he commanded them, saying, Wait for the promise of the Father; and on the fiftieth day He sent to them His Holy Spirit (in tongues) as of fire, and they spake together in the speech of all lands...

From The Eucharistic Thanksgiving of St Dioscorus

47

Mesqel, festival of the true cross

One of the most important feasts of the year is Mesqel in September. It is the commemoration of the finding of the true cross in Jerusalem by St Helena, the mother of the Emperor Constantine. This feast is celebrated in churches of both the Eastern and Western Christian traditions. However, the Ethiopian story records that she was led to the place where the cross was buried by lighting a bonfire and so, as a part of the celebration, bonfires are still lit today. The ashes are marked on the forehead of worshippers and spread on the fields to ensure good crops.

In the name of the Father, of the Son and the
Holy Spirit
* Do not forget the quiet and peaceful house of God*
Do not be fooled by the bright and shining lights of
the world
Come to the house of God
And find the inner peace you have been looking for.
* We believe in our Father*
We believe in the Son
We believe in the Holy Spirit
We have absolute belief in one God
* We believe in our Father, the Son and the*
Holy Spirit
We believe in the Trinity

A prayer before Mesqel

Mesqel celebrations. Lighting bonfires at Mesqel attracts large crowds in the centre of Addis Ababa.

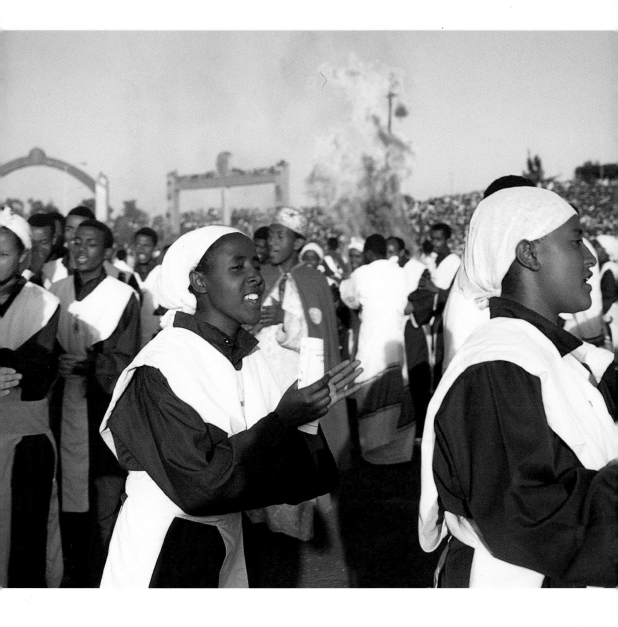

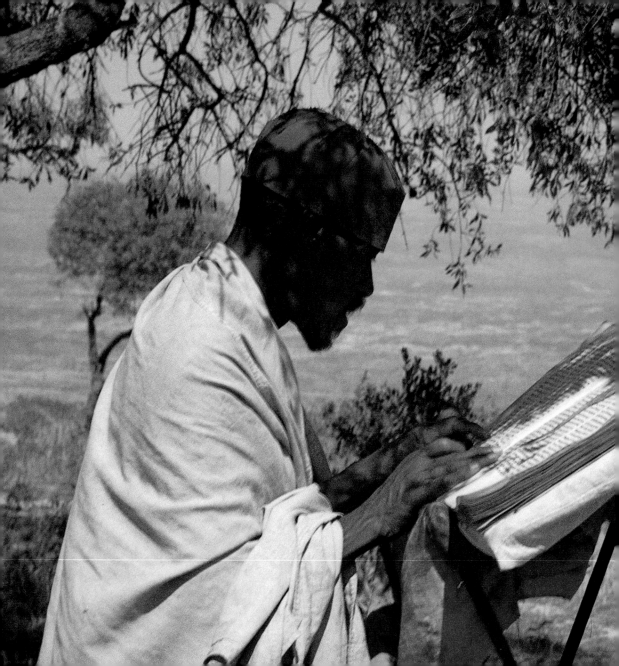

Christian
devotion

A priest of the Church of Debre Maryam Korkor. He reads the scriptures and prays for his people outside the church, which is set high up in the Greralta escarpment in the Tigre province. The view across the valley is stunning.

Instructions in prayer

For many Ethiopian Christians the practice of their faith involves not only regular attendance at church and festivals but also great personal discipline. This includes fasting—the faithful may observe up to one hundred and eighty fast days a year and the clergy as many as two hundred and fifty-six.

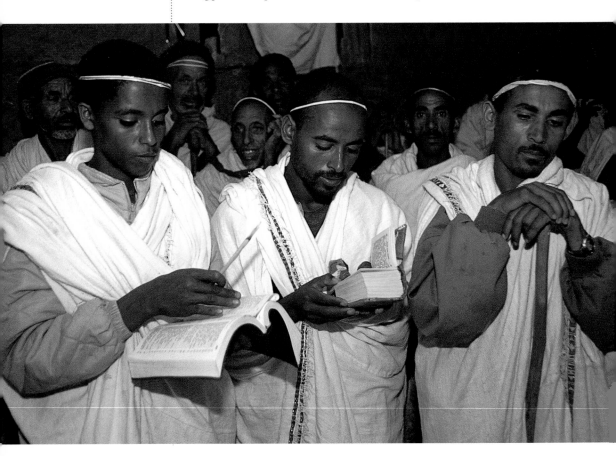

Although relatively few Ethiopian Orthodox Christians receive communion, attendance at church on feast days is commonly observed, with large numbers crowding excitedly into the church compounds.

Here is an example of instructions for daily prayer from the *Fetha Negest*, the Law of the Kings:

Firstly he should stand up as enjoined in the words of the Lord. 'When you rise up for prayer you shall stand up.' Secondly, he should gird himself with a girdle as the Lord said, 'Let your loins be girded.'

Thirdly, he should turn towards the East, for that is the direction from which Christ will appear in his second coming. Fourthly, he should make the sign of the cross from the forehead downward and from left to right.

Fifthly, he should recite the prayer in fear and trembling. Sixthly, he should kneel down and prostrate himself since the Gospel tells us that on the night of His passion our Lord prayed prostrating himself and kneeling.

From the *Fetha Negest*, the Law of the Kings

A taper lights the page as worshippers gather in church in the early hours of Easter Sunday morning.

Personal faith

Here are two examples of daily prayers taken from the *Fetha Negest*, the Law of the Kings:

My Lord and God Jesus Christ, Son of the Living God, I ask and beseech Thee to keep my soul and body in Thy fear; and take me not suddenly out of this world, but wait and be patient with me, that I may repent and bring unto Thee the fruit of repentance. Should the earth by reason of the multitude of my sins repair to Thee for my doom, say to it, 'Have patience.' Should the angels have recourse to thee at the multitude of my errors, say to them, 'Have patience.'

O loving Jesus, my sin is not a burden too heavy for Thee to bear. Sprinkle thy blood on me and cleanse me, change my death into life, my darkness into light, my weakness into strength; let not my life be beneath Thy regard: for Thou art He who desirest not the death of a sinner. Have patience with me in the multitude of Thy mercies, and bring me to Thyself in the multitude of Thy compassions, and forgive my sins and errors, and blot out all mine offences, and cause me to receive a recompense with those who have been well pleasing to Thee. For Thine is the power and the Kingdom, and to Thee be praise, world without end.

From the *Fetha Negest*

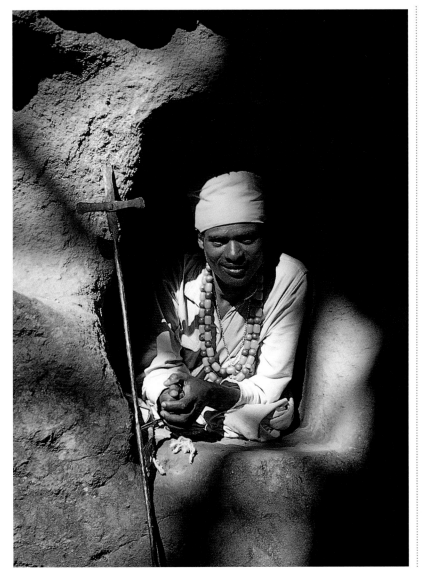

His yellow turban marks this man out as a monk and hermit. He is living in a rock cave near a church at Lalibela.

The whole church

This extract from the liturgy underlines the Ethiopian understanding that every worshipping community is part of a much greater whole. This is not just seen in terms of the church around the world, but of the continuity across time with all those who have been our forebears in the faith.

Remember all our fathers, brothers and sisters that have died in the Orthodox faith; may they rest in the bosoms of Abraham, Isaac and Jacob.

As for us, do not allow us to become victims of your wrath because of our lies, rebellion and sinful acts, but be merciful and preserve us from contact with heretics and Gentiles with the risk of defilement.

O Lord, grant us wisdom, strength and the understanding to avoid the temptations of Satan and his minions. Grant, O Lord, that we will always do your will and that our names will be inscribed in the Book of Life in the heavenly kingdom, with all your saints and martyrs, through Jesus Christ, our Lord.

From the *Fetha Negest*

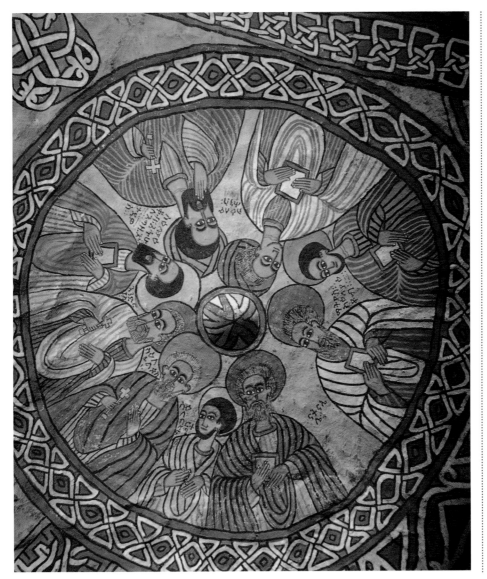

A unique circular mural on the ceiling of Abune Yemata Church in Tigray. Here Old Testament figures, such as Enoch and Elijah, are celebrated as forebears in the faith. The style of this painting shows an Islamic influence.

All creation

Nothing in creation is excluded from the Ethiopian sense of praise and thanksgiving. All is a gift of God and is to be valued and revered as such.

Send us the comfort of the Holy Spirit and in mercy and faith may the doors of the Holy Church be always open to us, and grant that we will always preserve the faith until our dying day.

O my Lord Jesus Christ, bring relief to those who are suffering and be pleased to grant them health. Protect our families and friends who have gone away, bring them back to their homes, in peace and in health.

Bless the winds of the sky (the priest blesses in the direction of the sky), and the rains and fruits of the earth, in accordance with your will and may joy and happiness be always sustained on the face of the earth (he blesses in the direction of the ground).

Grant peace to our country and to the scholars of your Church; to each and every one of us and to all foreign governments may your peace be extended.

Grant rest, O Lord, to all our fathers, brothers and sisters who have died in the faith.

Bless those, O Lord, who have given gifts of incense (he blesses the people), bread, wine, oil, decorations, books and vessels for the sanctuary, that Christ our God may reward them in the heavenly kingdom.

Bless those who are assembled here with us, begging your mercy; be propitious to them and to those that give alms.

Give comfort to all that are in any way distressed, imprisoned, exiled or in any way held captive; deliver them through your mercy, and be pleased to remember all those people who have asked us to remember them in our prayers, and be pleased to remember me, your sinful servant. O Lord save your people and bless them. Sustain them and grant them eternal life.

From the Prayer of Benediction

The paintings around the doors into the inner sanctuary of the Church of Debra Berhan Selassie show the way in which theology and history are included in Ethiopian iconography. The Trinity of Father, Son and Holy Spirit are shown above the crucifixion scene. To the left and right are events from the Old and New Testaments, together with Ethiopian history, and all is surrounded by a host of winged cherubs.

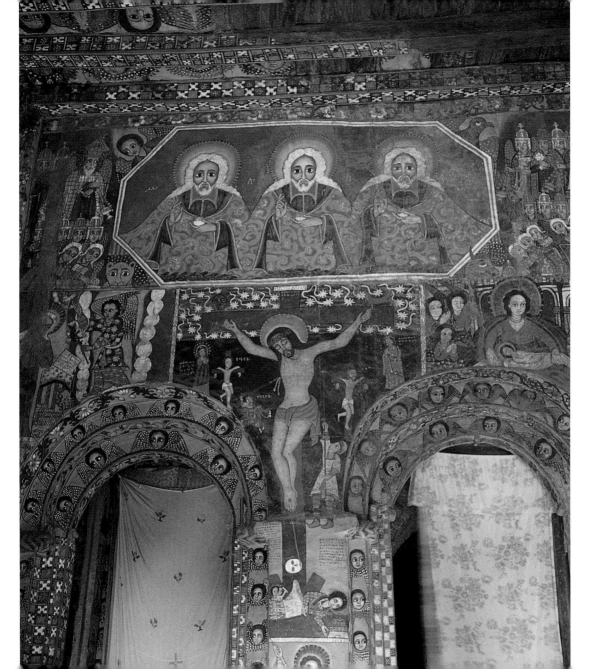

This portrait of Ethiopia's greatest hermit, Saint Gabra Manfas Qeddus of Zeqwala, includes a landscape of trees with a bird and wild animals.

*H*oly, holy, holy, perfect Lord of Hosts,
heaven and earth are full of the holiness
of your glory.
You have created all creatures with your word.
You carry them all without being weary,
and feed them all without ceasing.
You think about them all without forgetting
any.
You give to all without being diminished.
You water all the earth without running dry.
You watch over all without sleeping.
You hear us all without neglecting any.
While your presence fills every place,
they have told us about you
in a way we can receive.

From the Ethiopian Orthodox liturgy

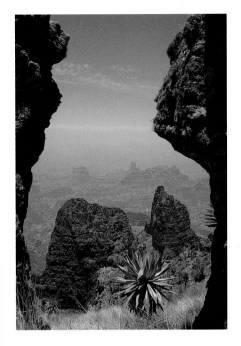

The beauty of creation in the awesome
highlands of Ethiopia. This view from the
Metgoga escarpment looks out over the
Simien National Park.

Blessings

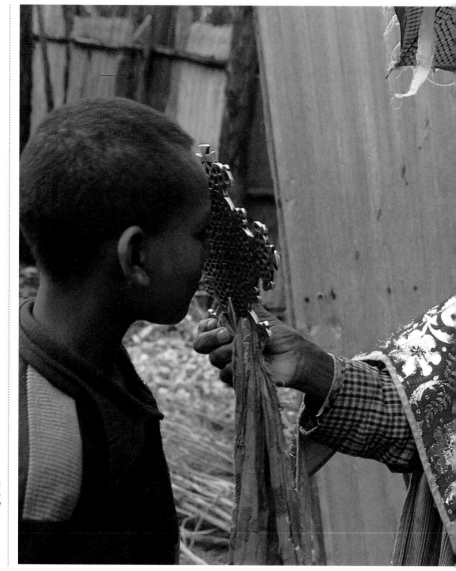

A priest pronounces a blessing by touching the child's forehead with a cross.

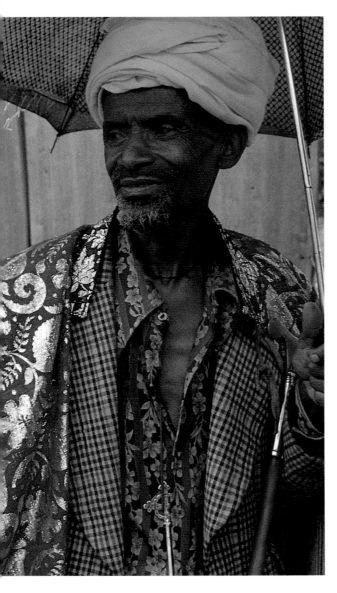

This prayer, just before the end of the liturgy, focuses the eyes and mind of the believer onto Christ, the source of salvation.

Pilot of the soul, Guide of the righteous, and Glory of the saints. Grant us, O Lord, eyes of knowledge ever to see Thee and ears also to hearken unto Thy word alone. When our souls have been fulfilled with Thy grace, create in us pure hearts, O Lord, that we may ever understand thy greatness, who art good and a lover of men. O our God, be gracious to our souls, and grant unto us Thy humble servants who have received Thy body and Thy blood, a pure and steadfast mind, for Thine is the kingdom, O Lord, blessed and glorious, Father and Son and Holy Spirit, now and ever and world without end.

From the Anaphora of Our Lord Jesus Christ

God bless you:
God make your heart bright,
Go home in peace
* In the name of Christ.*

Traditional Ethiopian blessing

For further reading

Briggs, P., *Guide to Ethiopia*, Bucks, 1995.

Budge, E.A.W., *The Book of the Saints of the Ethiopian Church, Vol I*, CUP, Cambridge, 1928.

Budge, E.A.W., *The Book of the Saints of the Ethiopian Church, Vol III*, CUP, Cambridge, 1928.

Budge, E.A.W., *The Book of the Saints of the Ethiopian Church, Vol IV*, CUP, Cambridge, 1928.

Budge, E.A.W., *The Queen of Sheba and her Only Son Menyelek*, London, 1922.

Caraman, P., *The Lost Empire: The Story of the Jesuits in Ethiopia*, Notre Dame, London, 1985.

Day, P.D., *Eastern Christian Liturgies: The Armenian, Coptic, Ethiopian and Syrian Rites*, Irish University Press, Shannon, 1972.

Fortescue, A., *The Lesser Eastern Churches*, London, Catholic Truth Society, 1913.

Grillmeier, A., *Christ in Christian Tradition, Vol 2, Part 4*, Mowbray, London, 1996.

Hancock, G., *The Sign and the Seal: A Quest for the Lost Ark of the Covenant*, Mandarin, London, 1992.

Harden, J.M., *An Introduction to Ethiopic Christian Literature*, SPCK, London, 1926.

Harden, J.M., *The Anaphoras of the Ethiopic Liturgy*, SPCK, London, 1928.

Harden, J.M., *The Ethiopic Didascalia*, SPCK, London, 1920.

Heldman, M. and Grierson, R., *African Zion: The Sacred Art of Ethiopia*, Yale, New Haven, 1993.

Hill, H., *Light from the East: A Symposium on the Oriental Orthodox and Assyrian Churches*, Anglican Book Centre, Toronto, 1988.

Mercer, S.A.B., *The Ethiopic Liturgy*, Mowbray, London, 1915.

O'Leary, D.L., *The Ethiopian Church*, SPCK, London, 1936.